Ready-made inky splats for you to adapt,
embellish and draw into.
Be creative and have fun!

THE
INKY™
BLOT

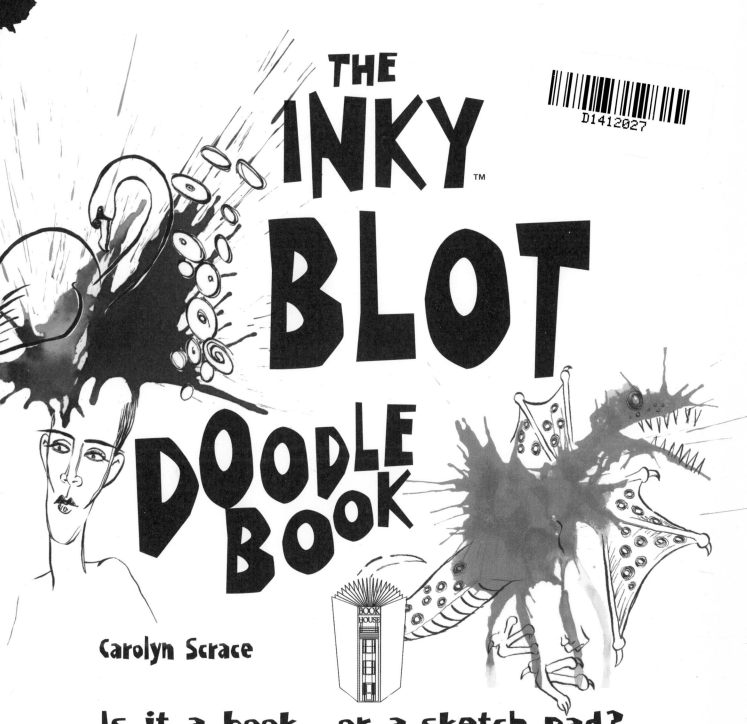

DOODLE
BOOK

Carolyn Scrace

BOOK HOUSE

Is it a book...or a sketch pad?
Is it a personal journal?
It's whatever you want it to be!

SALARIYA

Published in Great Britain in MMXIII by
Book House, an imprint of
The Salariya Book Company Ltd
25 Marlborough Place, Brighton BN1 1UB
www.salariya.com
www.book-house.co.uk

PB ISBN-13: 978-1-908177-51-3

1 3 5 7 9 8 6 4 2

A CIP catalogue record for this book is available
from the British Library.

Printed and bound in China.

Visit our **new** online shop at
shop.salariya.com
for great offers, gift ideas, all our new
releases and **free** postage and packaging.

**PAPER FROM
SUSTAINABLE
FORESTS**

Be bold!
Be creative!
Be imaginative!

Upload your own doodles to: **flickr** */groups/inky*

Introduction

Ink splats can draw out anyone's creative talents in a very direct and entertaining way. What the imagination sees in an ink splat can provide limitless inspiration for artistic expression.

Rules

The only rules are that you must be creative, spontaneous, daring and bold. The only essentials are that you have fun and thoroughly enjoy yourself as you draw!

Inspiration

Most pages include ready-drawn ideas or little hints to help you get started.

Interpretation

Interpret and embellish the splats in The Inky Blot Doodle Book in whatever way you want. Doodle on each page with black ink, felt-tip pens, coloured crayons, or even add inky splats of your own.

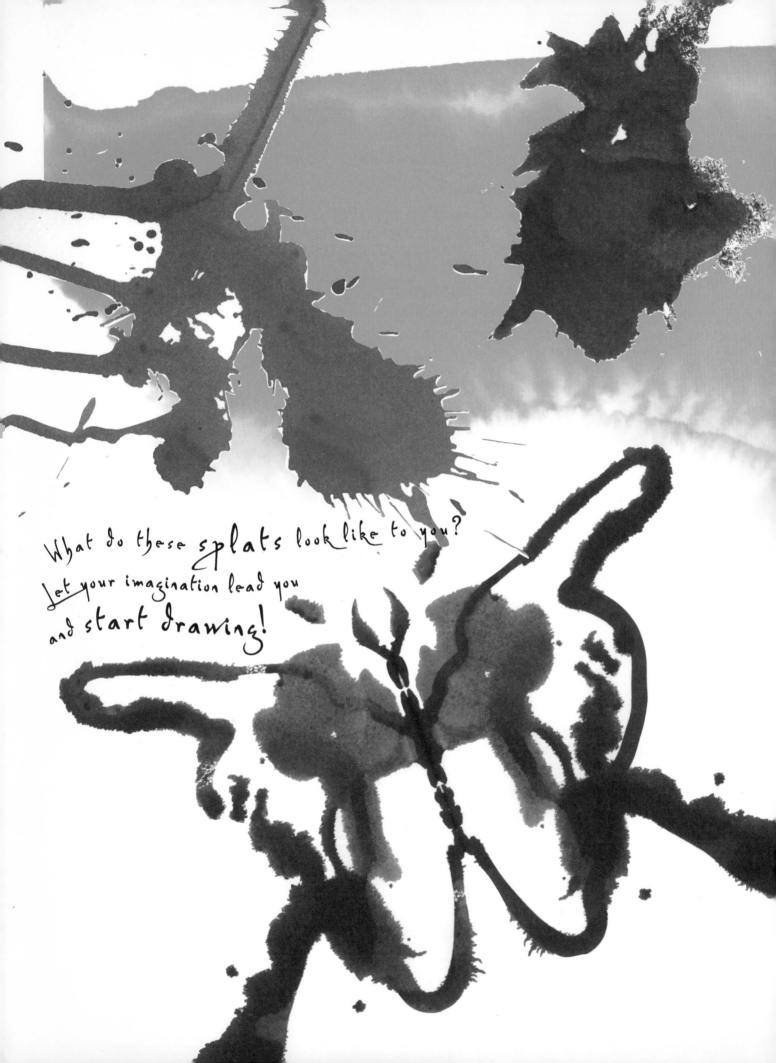

What do these **splats** look like to you?
Let your imagination lead you
and start **drawing!**

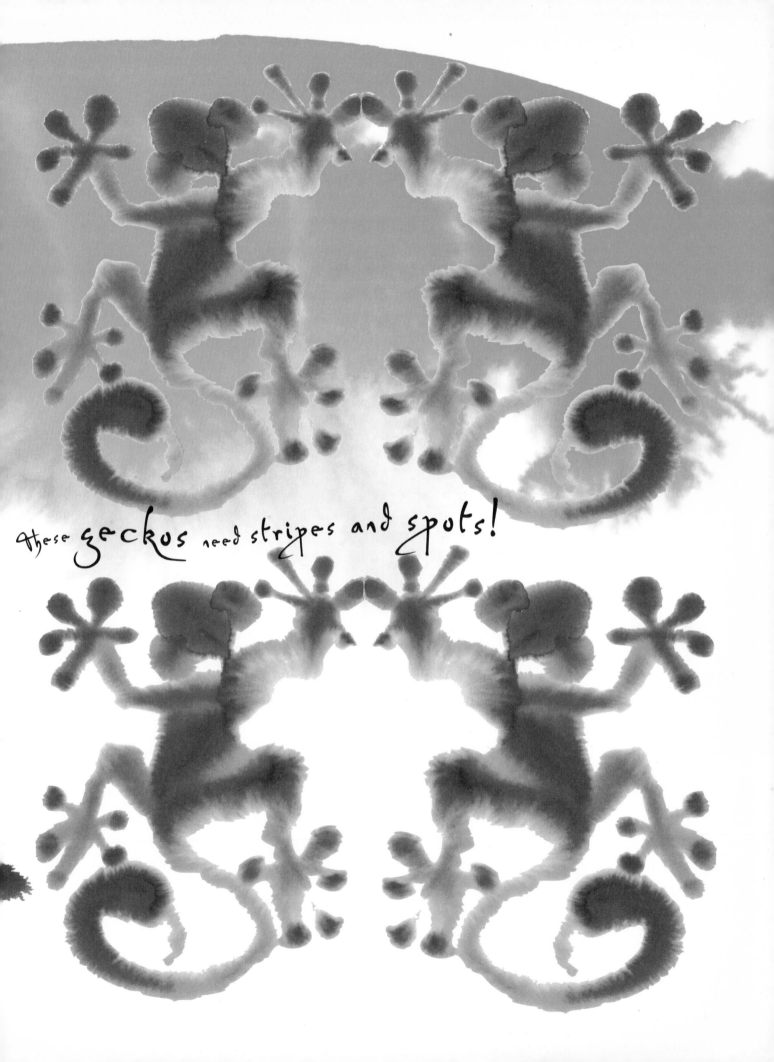

these geckos need stripes and spots!

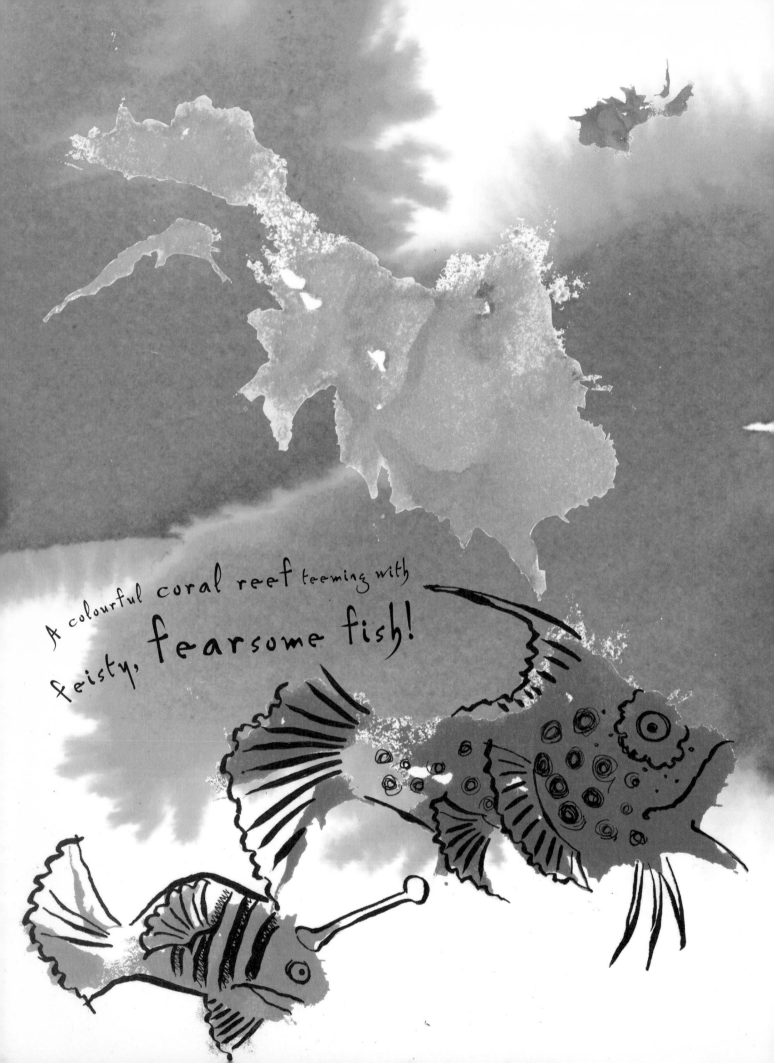

A colourful coral reef teeming with feisty, **fearsome fish!**

Draw a branch for the monkey to sit on. Add leaves and some tasty berries!

Try sketching a forest in the background, with colourful butterflies and birds. Draw some beetles in the foreground!

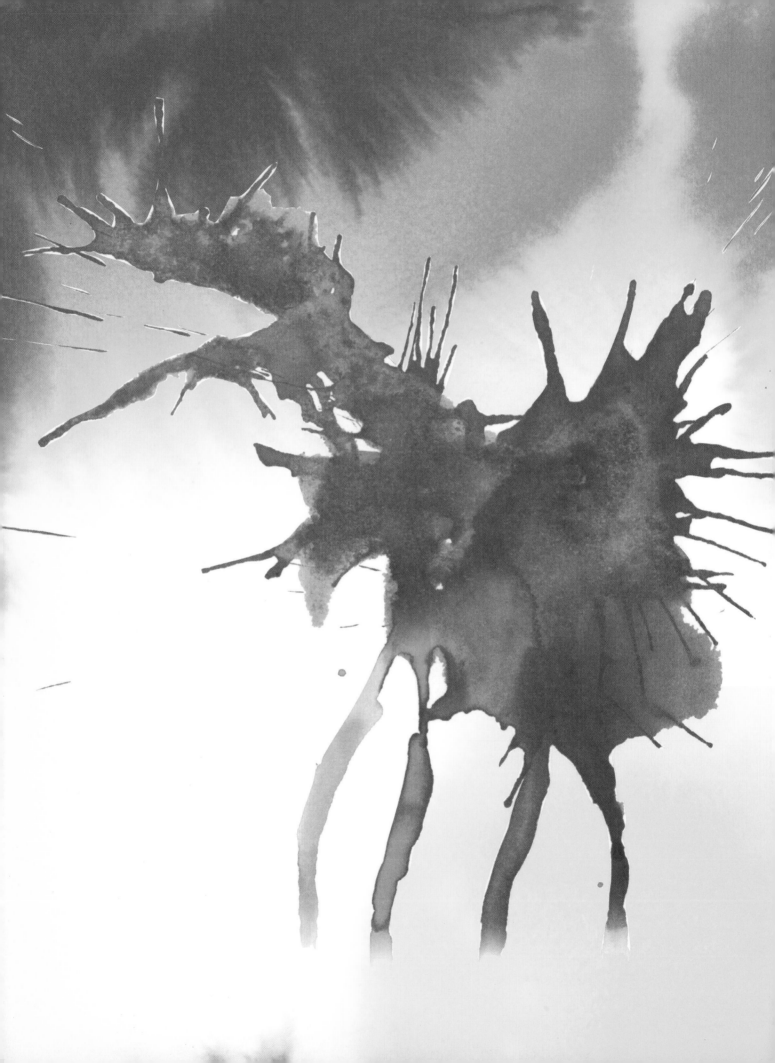

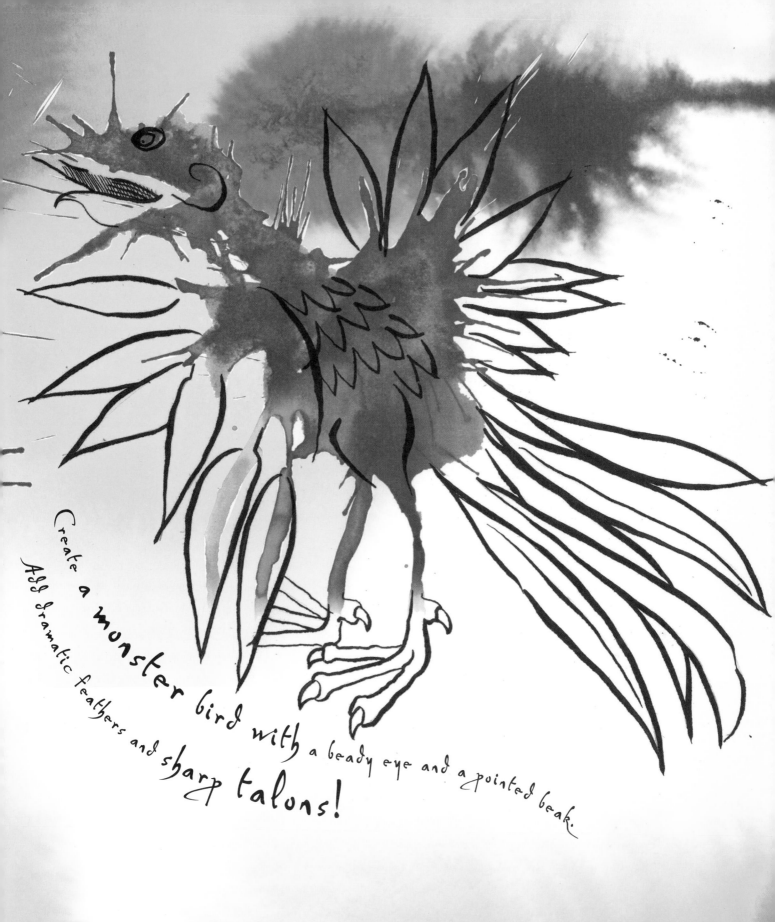

Create a monster bird with a beady eye and a pointed beak. Add dramatic feathers and sharp talons!

This cat would look good in stripes...
and would love a mouse to chase!

Add almond-shaped eyes, a mouth,
long curly whiskers and a tiny pink nose!

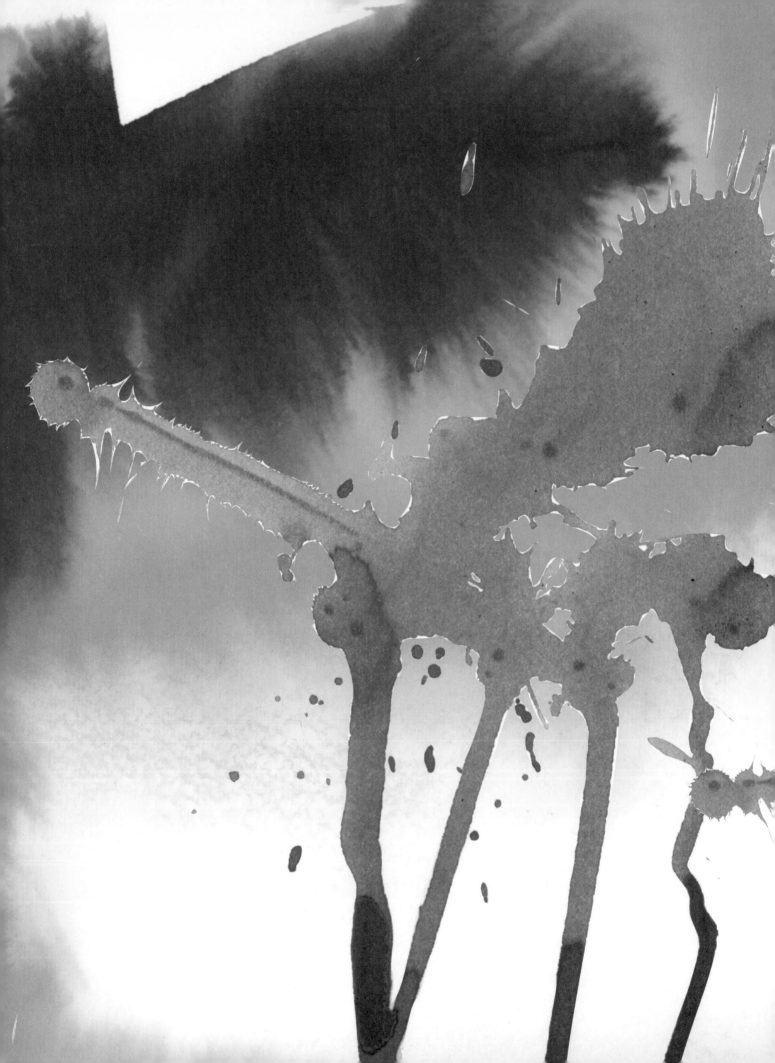

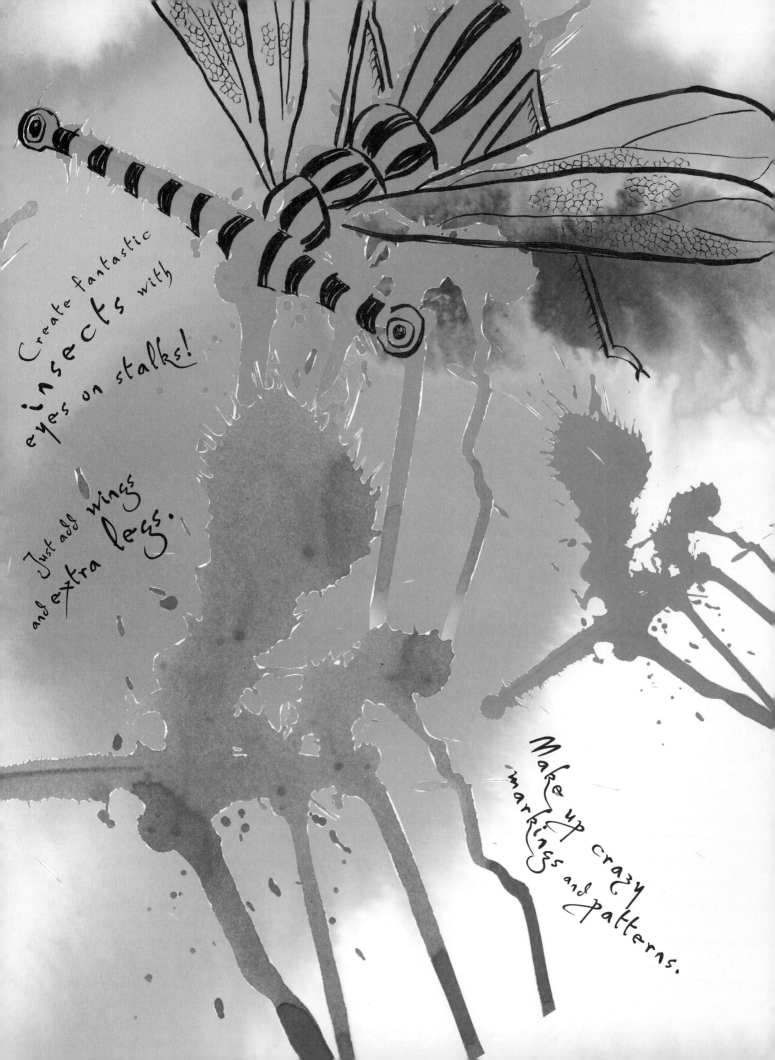

Create fantastic
insects with
eyes on stalks!

Just add wings
and extra legs.

Make up crazy
markings and
patterns.

This fire-breathing dragon needs wings, powerful legs and a long, serpent-like tail!

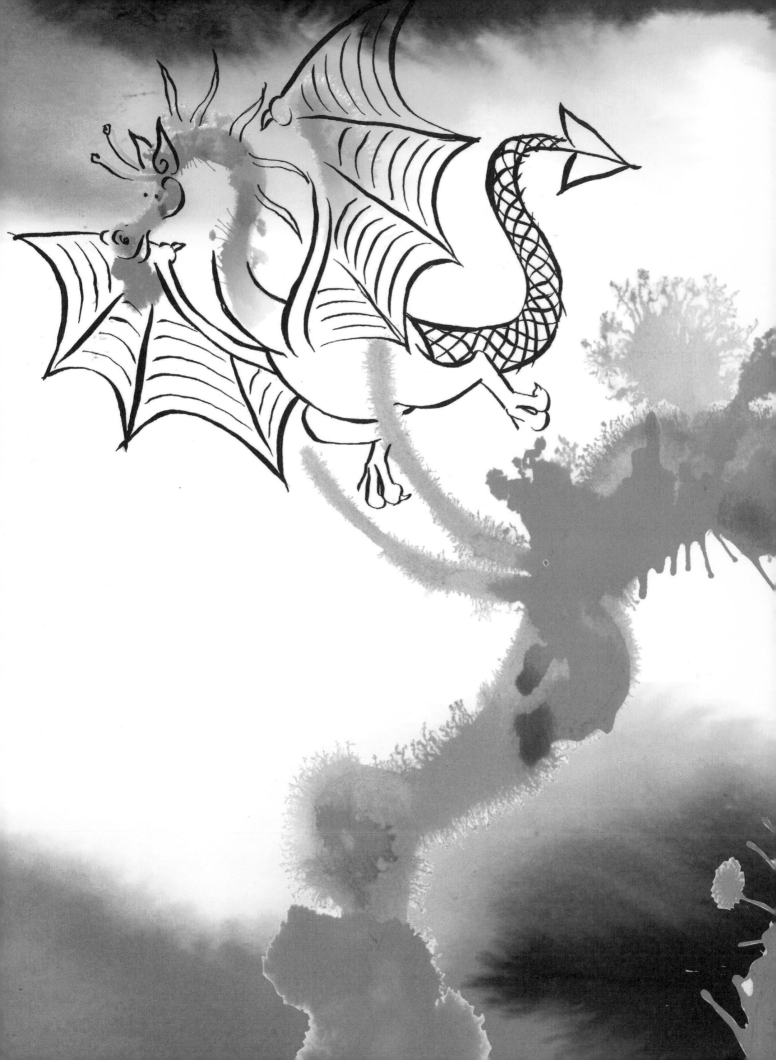

A fantasy city with towering turrets, houses on stilts, winding staircases...

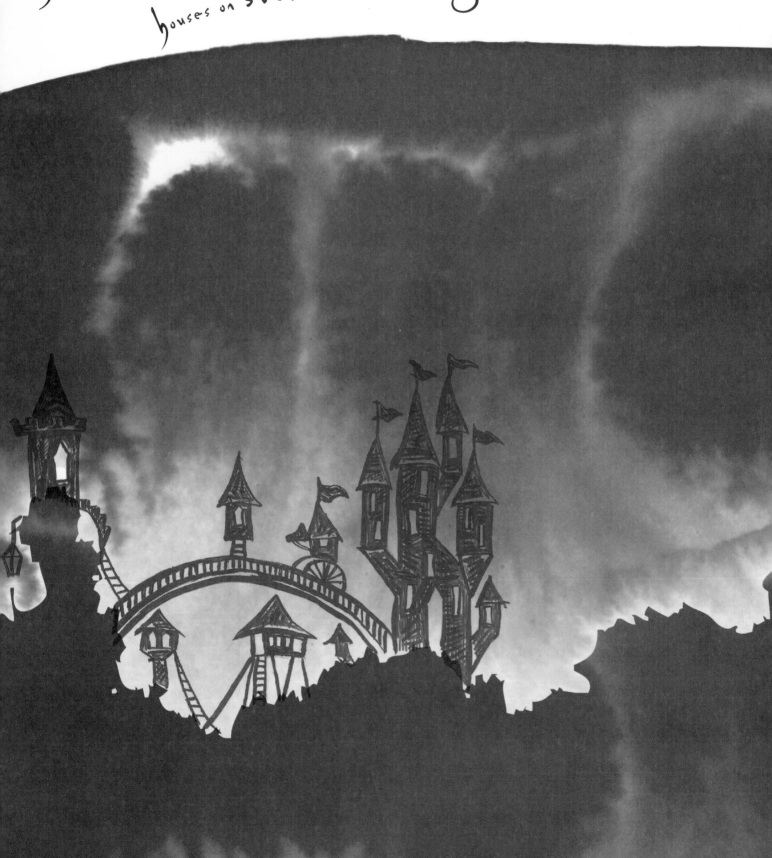

...and weird vehicles...

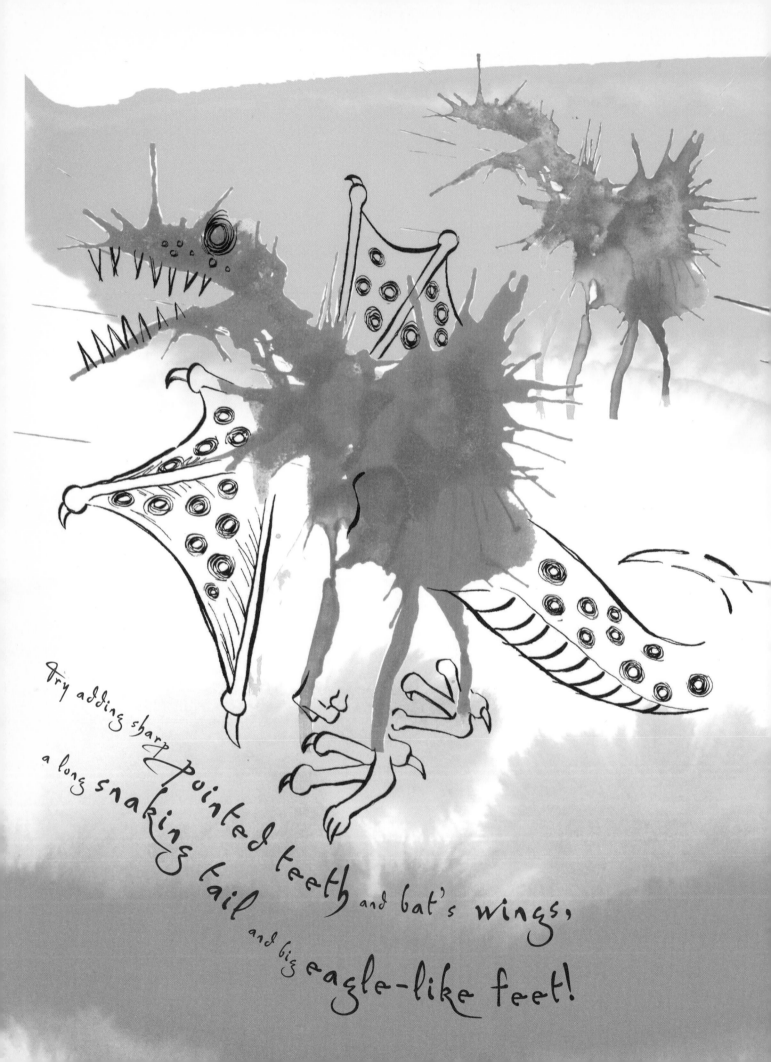

Try adding sharp pointed teeth and bat's wings, a long snaking tail and big eagle-like feet!

A fire-breathing monster?

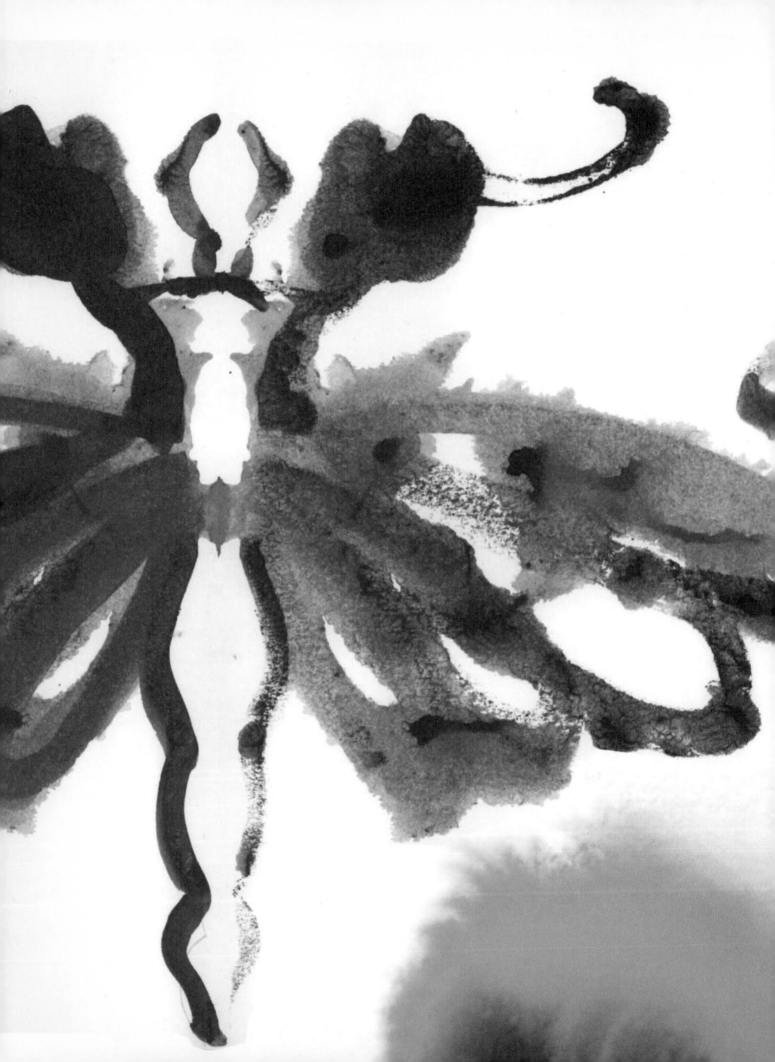

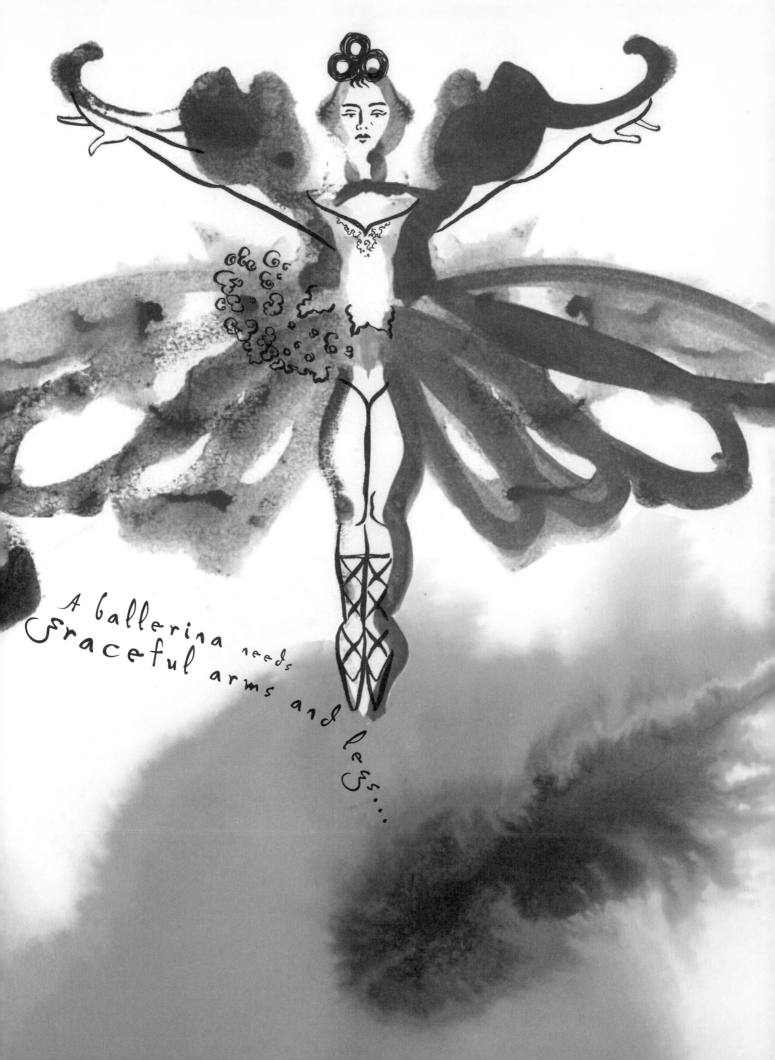

A ballerina needs Graceful arms and legs...

Finish off these ghastly, gruesome monsters!
Add gnashing teeth and ghoulish bodies!

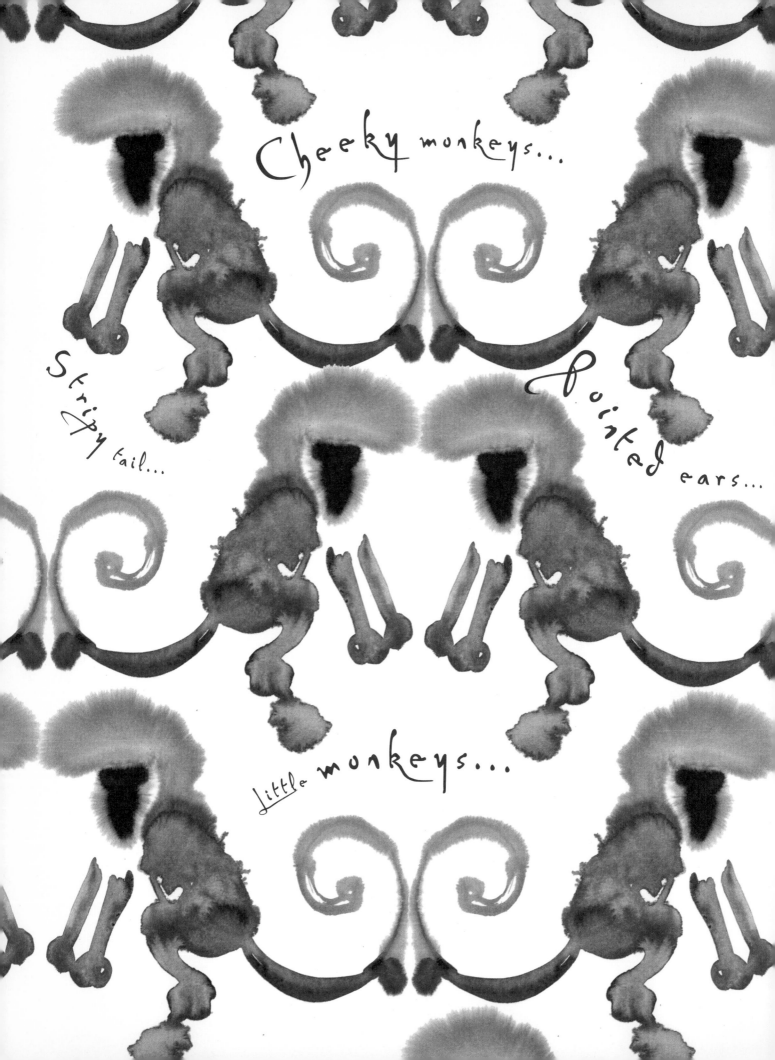

Cheeky monkeys...

Stripy tail...

Pointed ears...

Little monkeys...

Wise monkeys...

A lion's mane...

Big eyes...

Monkey business...

Draw branches and leaves...
...squirrels, birds,
butterflies and deer...
beams of sunlight...
a carpet of flowers...

Decorate these delicate
butterfly wings...

Add some beautiful colours
and markings!

Draw in some flowers for
the butterflies to land on!

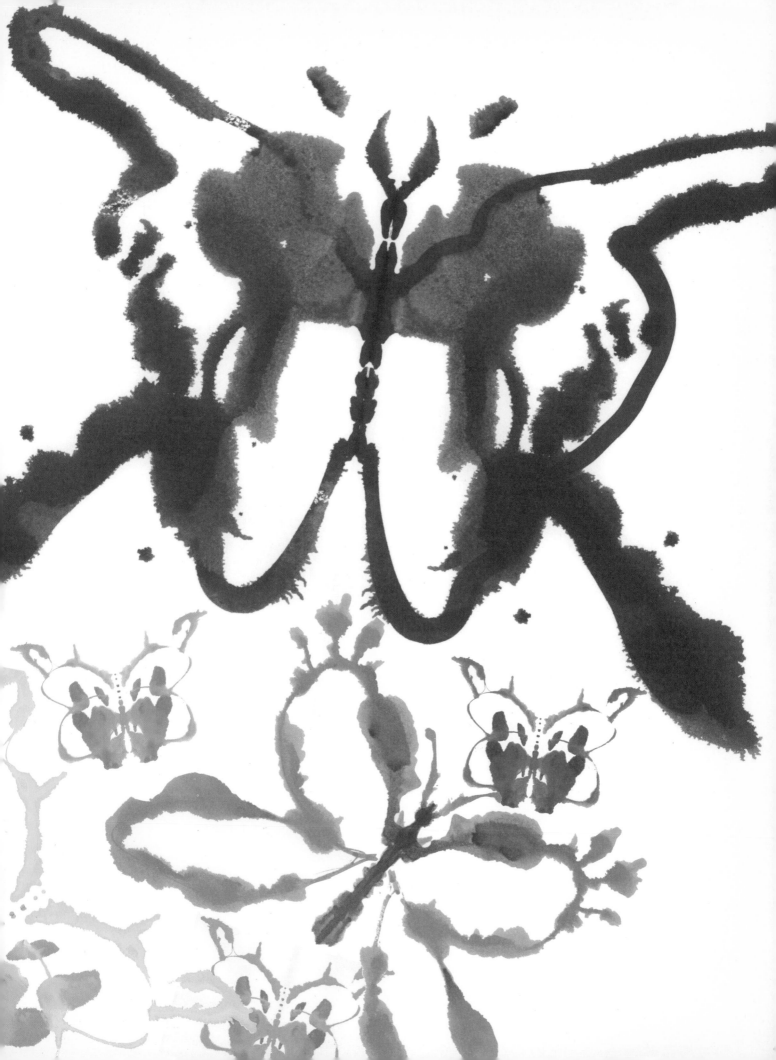

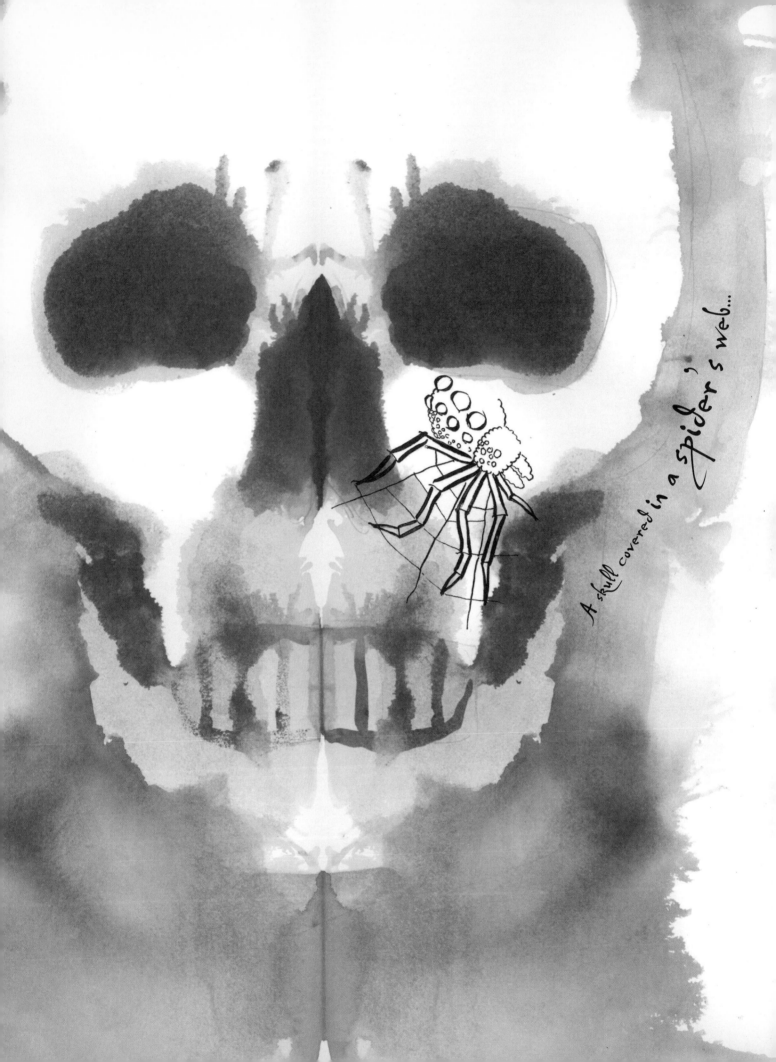

A skull covered in a spider's web...

A metal skull with rivets, entwined with ivy...?

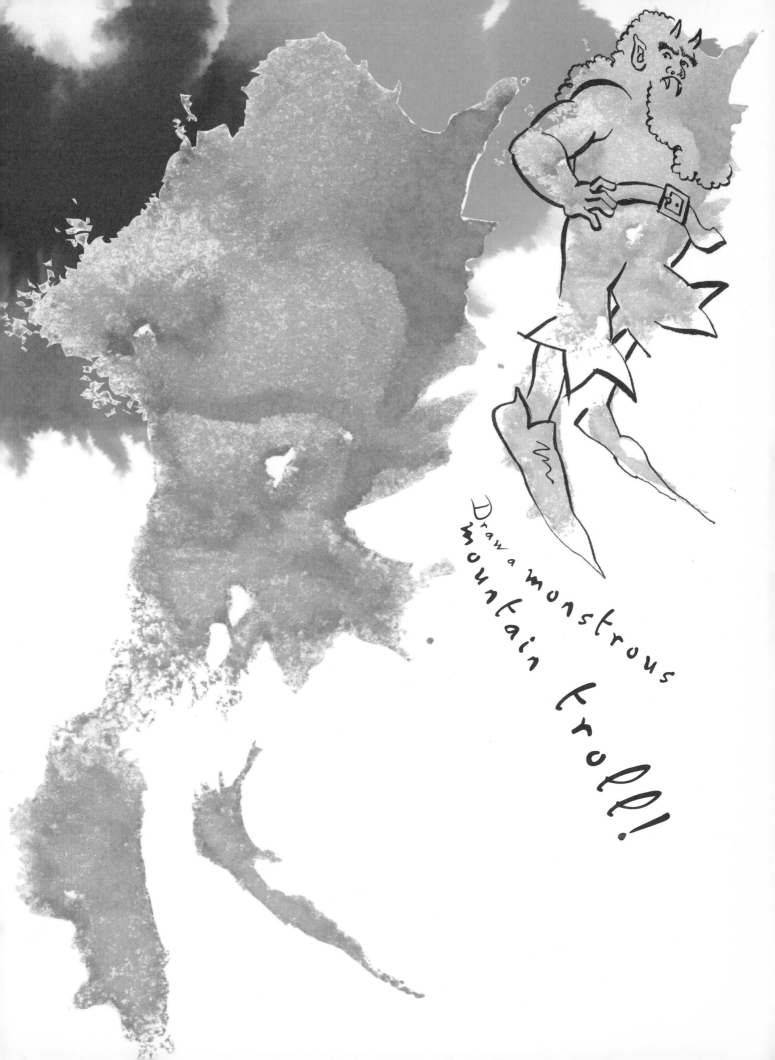

Draw a monstrous mountain troll!

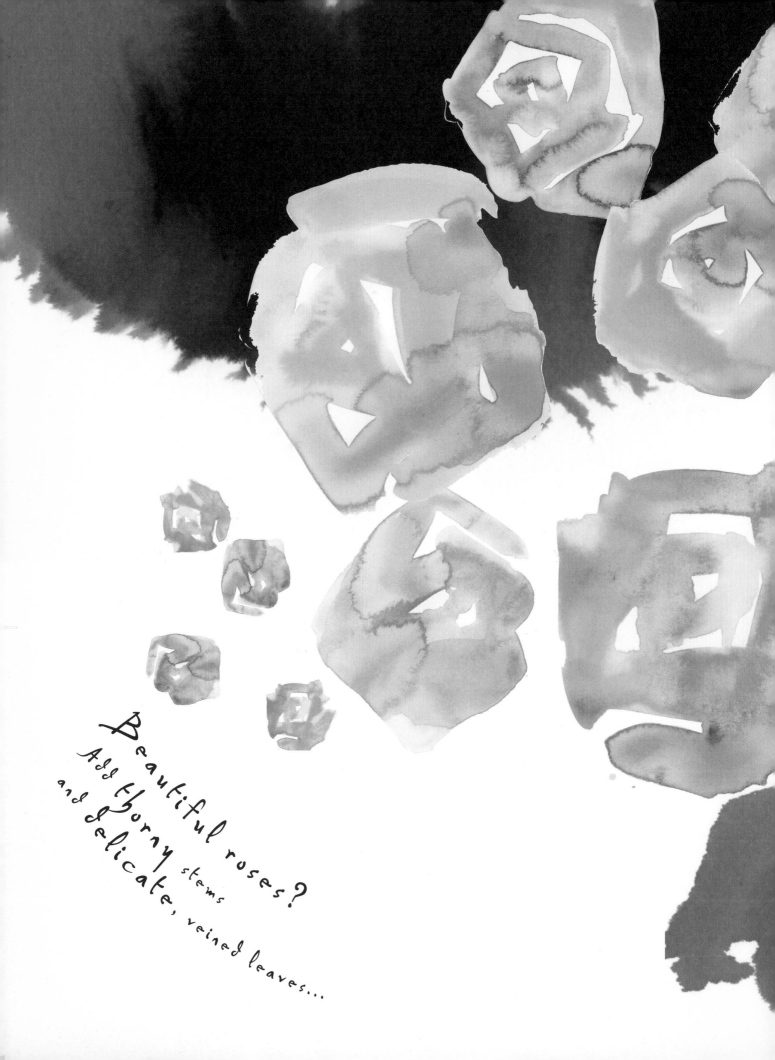

Beautiful roses?
Add thorny stems
and delicate, veined leaves...

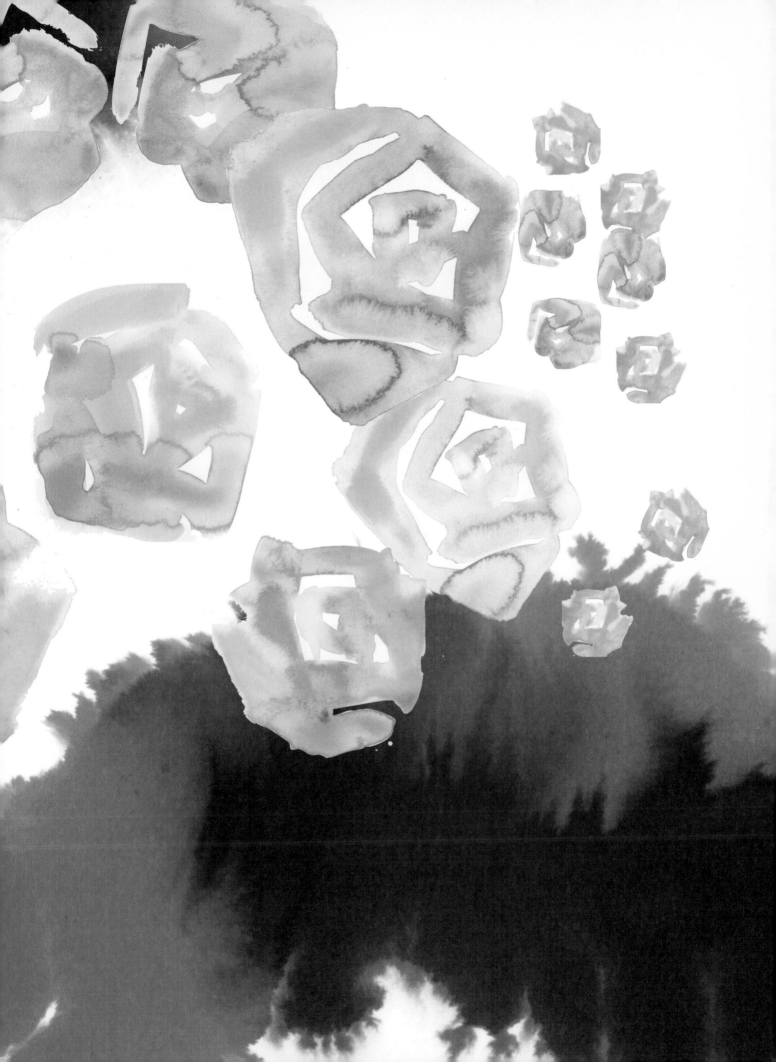

This gecko needs some insects to eat!

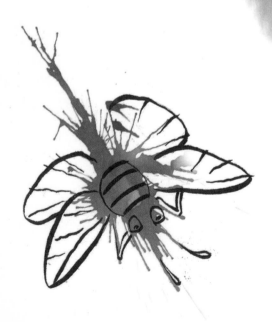

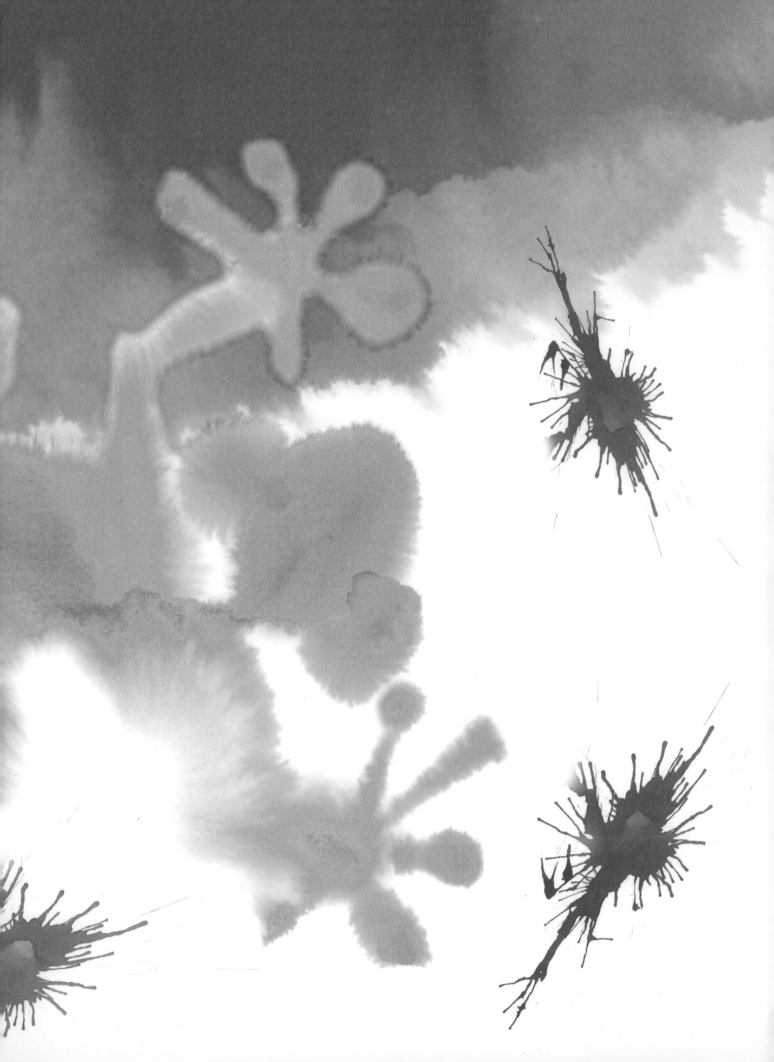

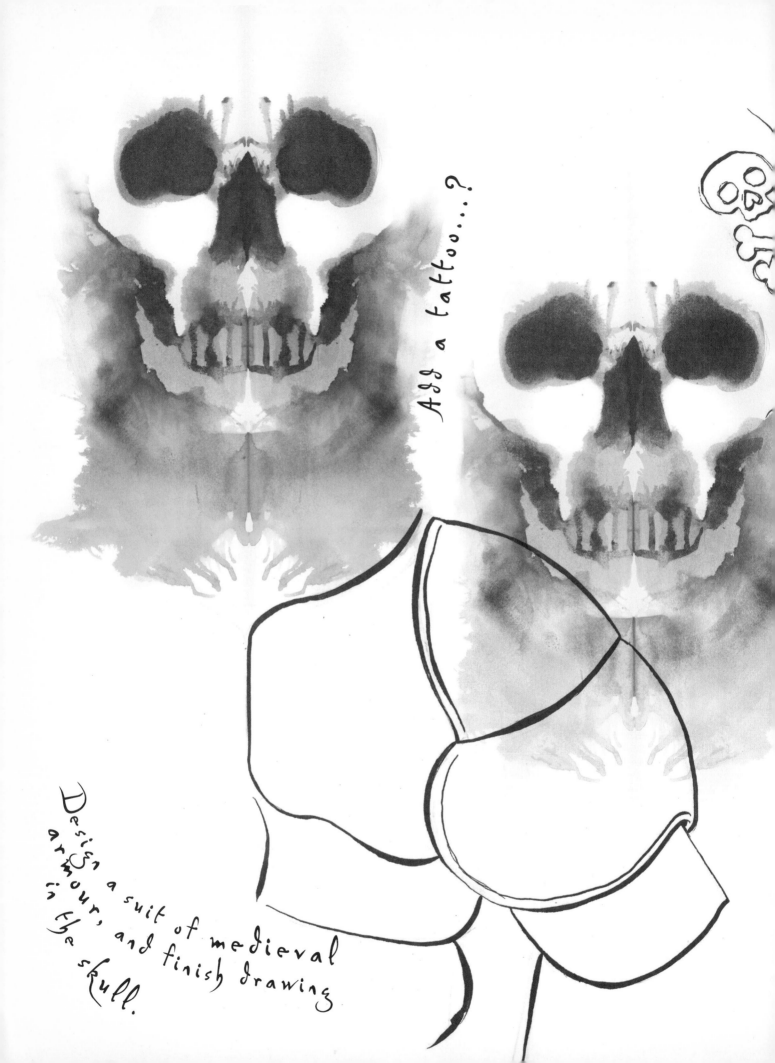

Add a tattoo...?

Design a suit of medieval armour, and finish drawing in the skull.

A feather headdress...

Draw a crown with lace-like edging...

A skull-shaped pendant!

Paisley patterns...

Add details to create a handsome seahorse.

Draw in a leafy sea dragon...

Let your **imagination** fly!
What can you create?

...or a weedy
sea dragon!

Scruffy cats...

Spotted cats...

Stripy cats...

Silly cats...

Aristocats...

...big feet...

Small cats...

Pretty cats...

Alley cats...

...black nose...

Give some cats big eyes and long whiskers!

Big cats...

Ugly cats...

...small feet...

Pampered cats...

Fat cats...

...and thin cats!

Mean cats...

...pink nose...

A wizard's hat can be adorned with toads, snakes and bats!

and Add spiders' webs and snails!

Draw in a wizard with glasses and a long flowing beard.

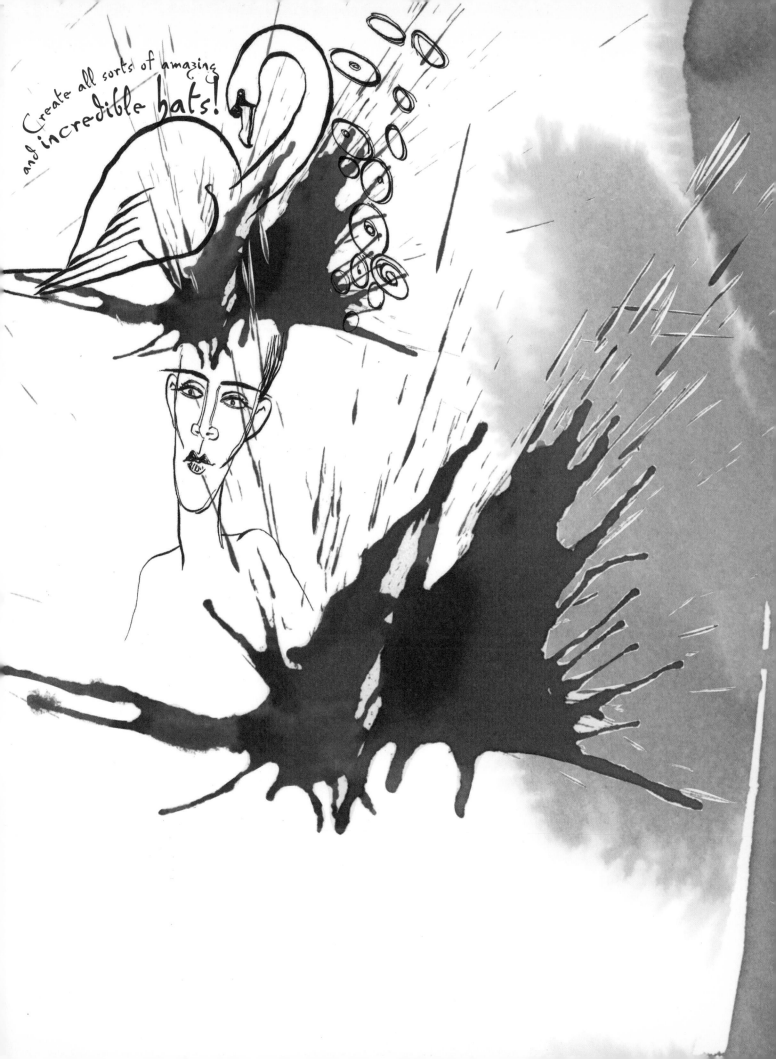

Create all sorts of amazing and incredible hats!

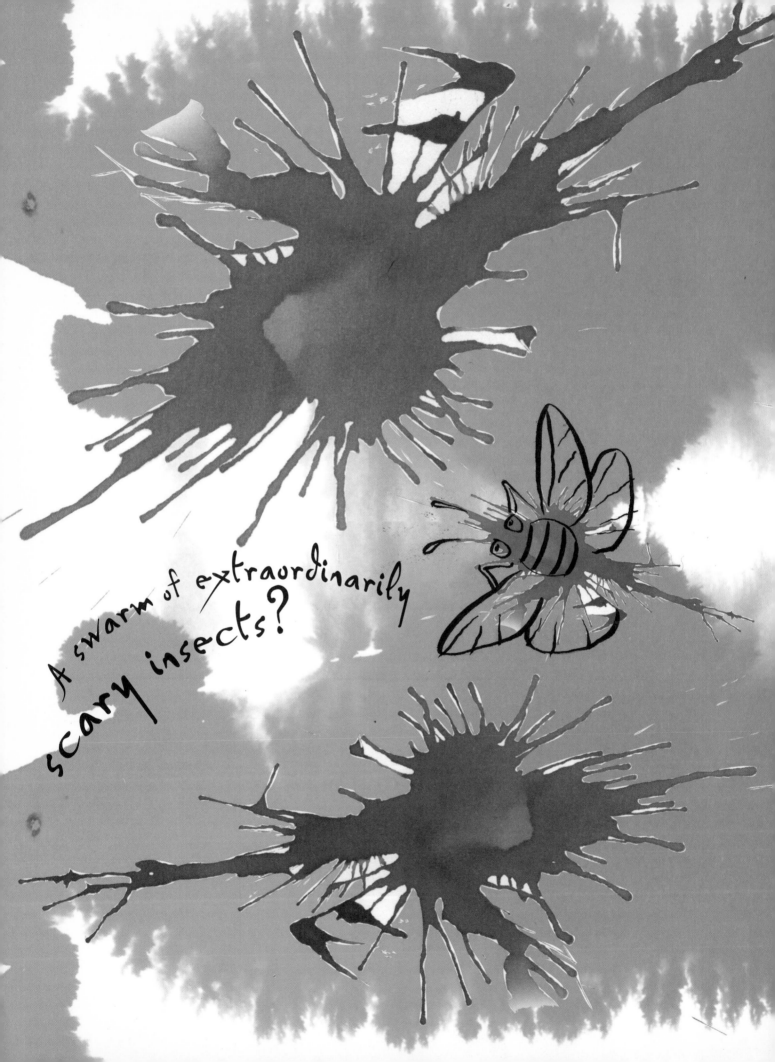

A swarm of extraordinarily scary insects?

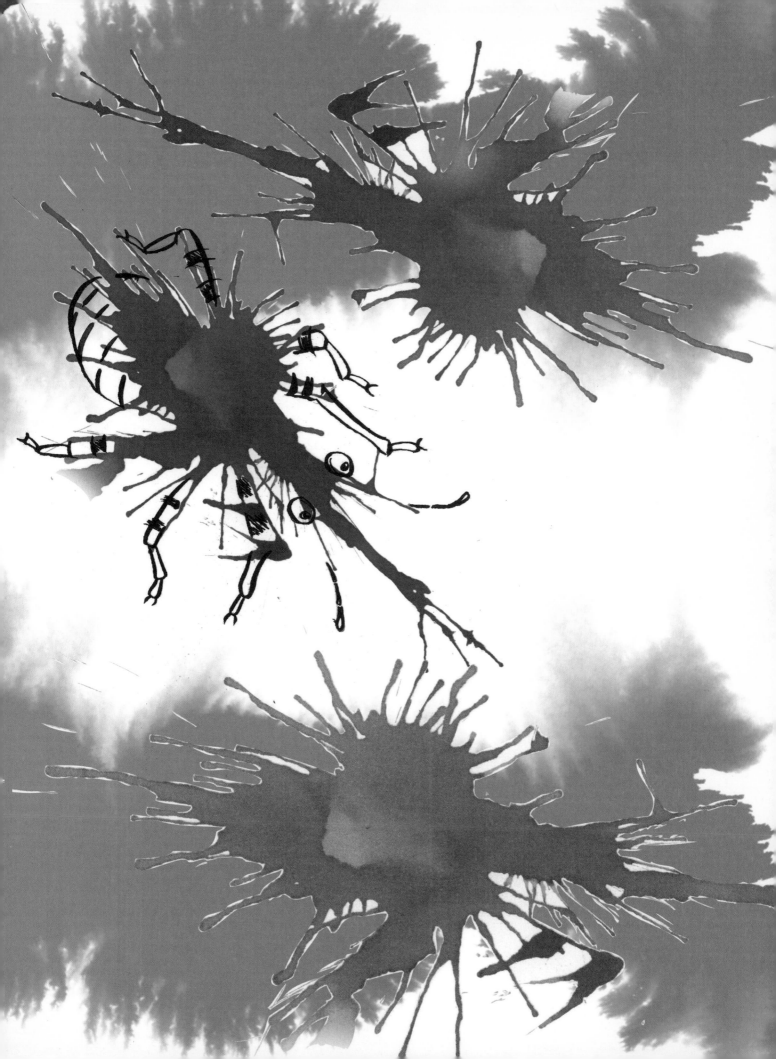

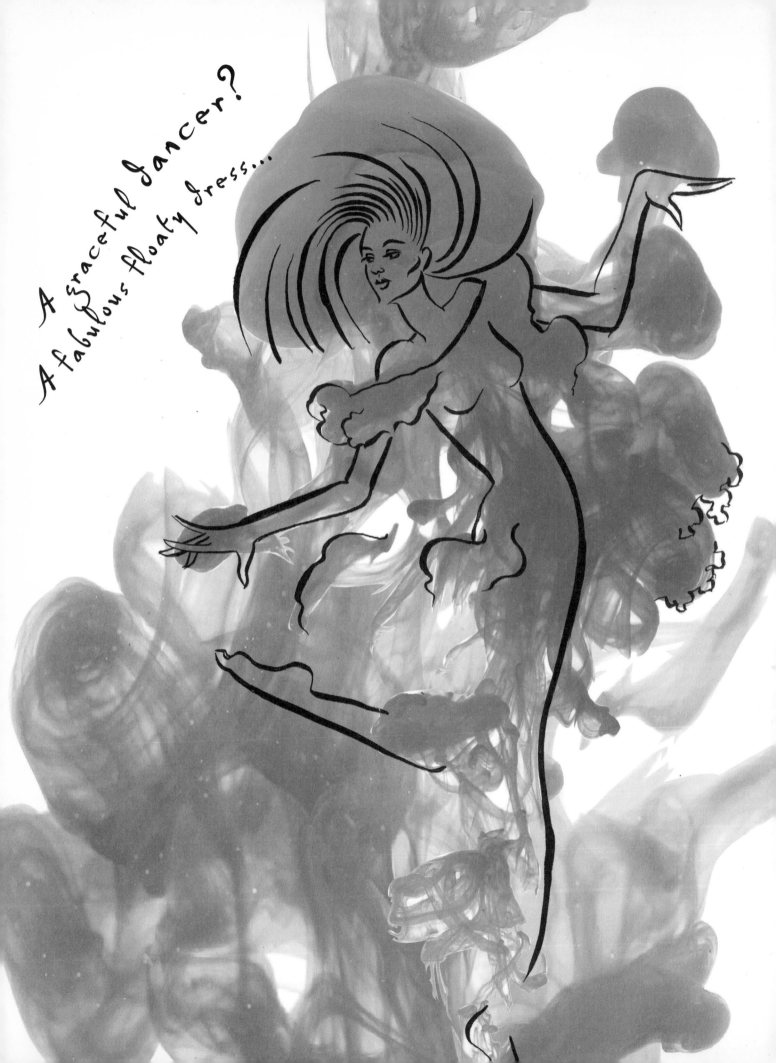

A graceful dancer?
A fabulous floaty dress...

Draw in Oberon and Titania, the beautiful Fairy King and Queen!

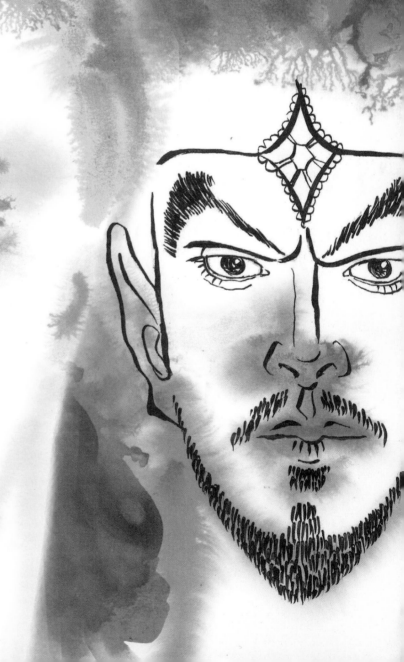

Design a range of doggie t-shirts...

Design a range of doggie hoodies...

Design a dog...

Design a range of doggie raincoats...

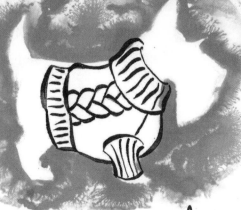

Design a range of doggie jumpers...

Design a range of doggie accessories...

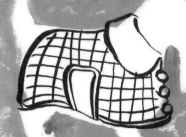

Design a range of doggie winter coats...

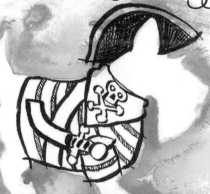

Design a range of doggie party clothes...

A spiral horn
turns a horse into
a magical unicorn!

Draw in multicoloured stripes
to create a rainbow
zebra!

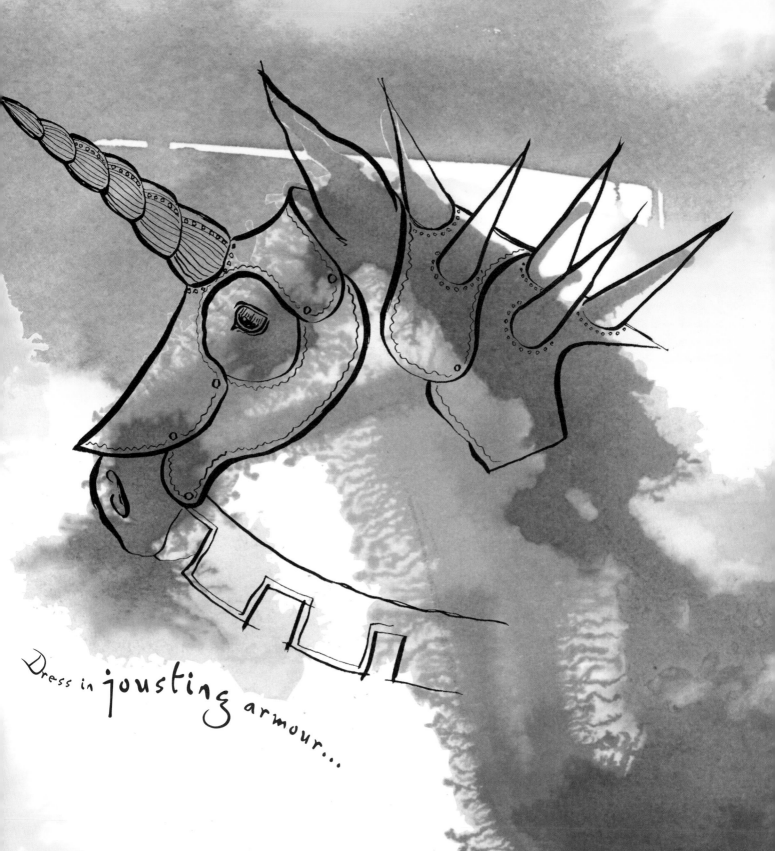

Dress in jousting armour...

A magical cave?
Add stalactites and stalagmites...

...and draw in some extraordinary
creatures that live there...

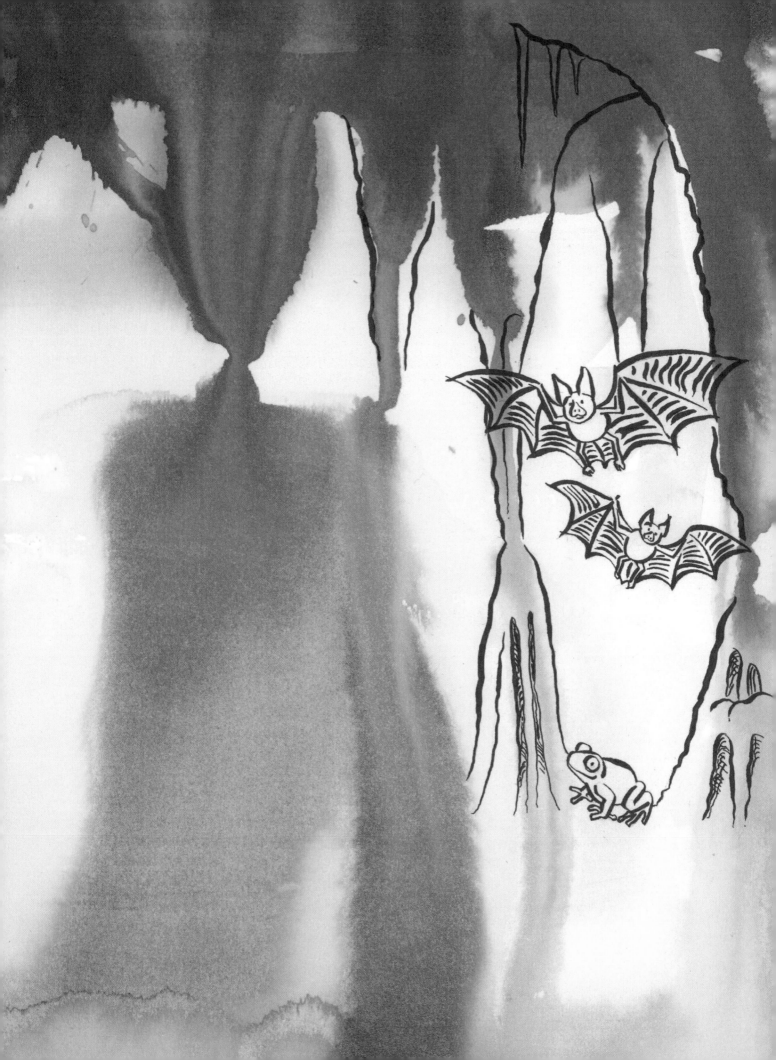

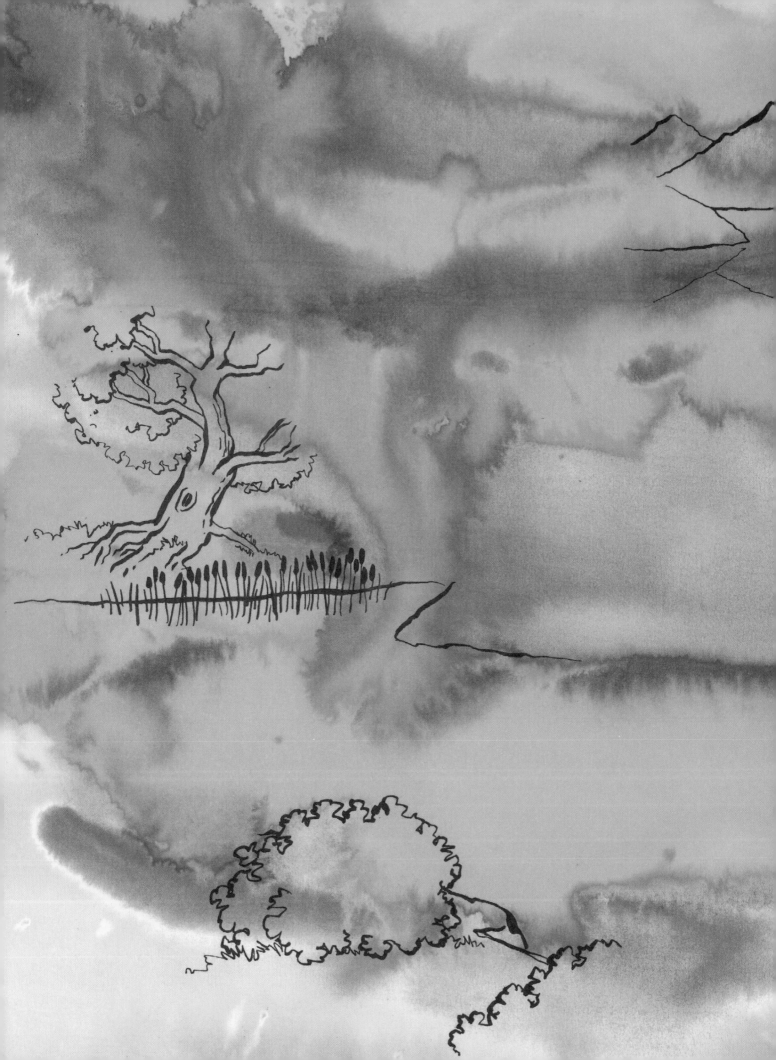

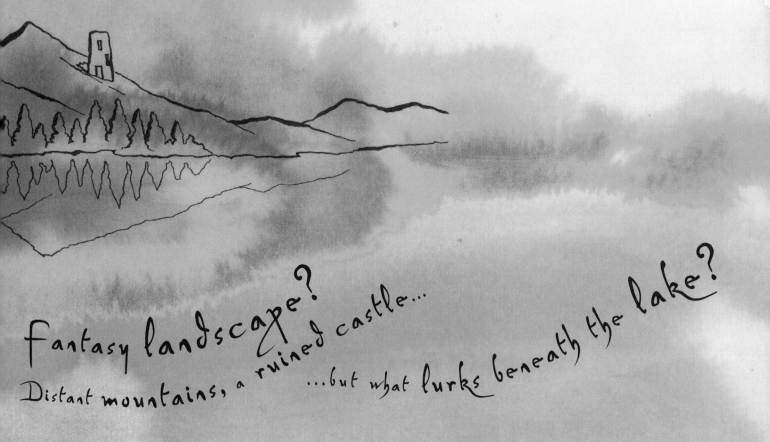

Fantasy landscape?

Distant mountains, a ruined castle...

...but what lurks beneath the lake?

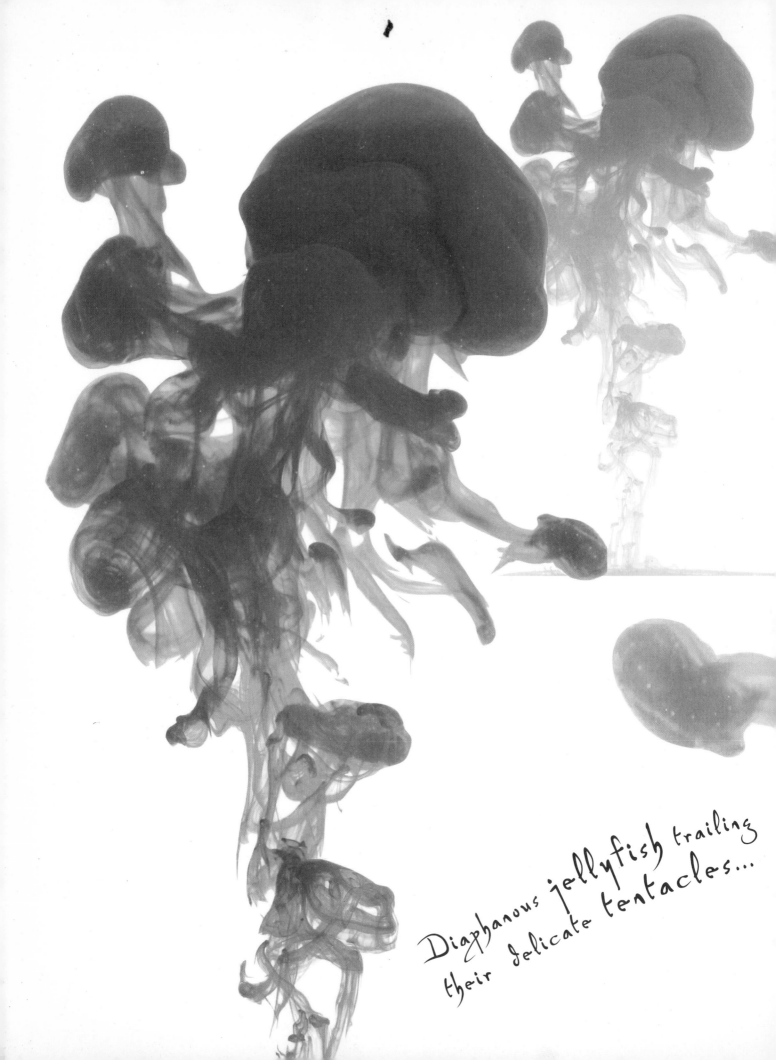

Diaphanous jellyfish trailing their delicate tentacles...